REDISCOVERING FRA ANGELICO

REDISCOVERING FRA ANGELICO

A Fragmentary History

With essays by

Laurence B. Kanter and Carl Brandon Strehlke

Exhibition and Catalogue Organized by Clay Dean

Yale University Art Gallery · New Haven, Connecticut · 2001

This catalogue has been made possible by a generous grant from
The Samuel H. Kress Foundation, supported by the Robert Lehman Exhibition
and Publication Fund, and is published in conjunction with the exhibition

Rediscovering Fra Angelico: A Fragmentary History

Yale University Art Gallery

28 September – 30 December 2001

Library of Congress Cataloguing-in-Publication Data

Angelico, fra, ca. 1400–1455.
 Rediscovering Fra Angelico: a fragmentary history / exhibition and catalogue
 organized by Clay Dean; with essays by Laurence B. Kanter and Carl Brandon Strehlke.
 p. cm.
 Exhibition catalogue.
 ISBN 0-89467-950-3
 1. Angelico, fra, 1400–1455 — Exhibitions. I. Dean, Clay. II. Kanter, Laurence B.
 III. Strehlke, Carl Brandon. IV. Title.

 ND623.F5 A4 2001

 759.5 — dc21

 2001045458

CONTENTS

INTRODUCTION

REDISCOVERING FRA ANGELICO: A FRAGMENTARY HISTORY provides students, scholars, and the public an opportunity to explore the history of the fragmentation of Renaissance art through the examination of four fifteenth-century panels, which were only recently confirmed to belong to a single triptych by the great Renaissance master Fra Angelico (ca. 1395/1400–1455) (Plate 1). This group of objects consists of two panels from the Yale University Art Gallery, one depicting the Angel Gabriel announcing the birth of Christ, the other depicting the Virgin Annunciate (Plate 2) and two panels from The J. Paul Getty Museum, one showing Saint Francis and a Bishop Saint and the other Saints John the Baptist and Dominic (Plate 3). The exhibition itself brings these panels together for the first time since their separation.

Over time scholars have reunited widely dispersed panels from Italian altarpieces in order to understand their original appearance and function. After the two Yale panels by Angelico were cut from their original structure, the pieces were reassembled into a unified rectangular format, possibly to appeal to a potential buyer. Laurence B. Kanter, Curator-in-Charge of the Robert Lehman Collection at The Metropolitan Museum of Art, first made the association of the Yale pictures with the corresponding ones in The J. Paul Getty Museum. This was later confirmed by technical evidence gathered by the conservation departments of the two institutions that began collaborating in 1998 on a restoration project of Yale's early Italian paintings.

Extending a well-established tradition of providing assistance to other museums, the painting conservation department of The J. Paul Getty Museum offered to collaborate with the Yale University Art Gallery. The resulting partnership stimulated a major effort to examine and restore paintings in Yale's early Italian collection, a good number of which had undergone extensive restoration from 1952 to 1972. Working with the University's Department of History of Art and art historians and scholars of the Italian Renaissance outside Yale, the Departments of Conservation and European and Contemporary Art at the Yale University Art Gallery undertook a survey of the Gallery's Italian paintings to identify those pictures that would most benefit from restoration. The curators, conservators, and consulting experts determined treatment priorities based on the quality and significance of the works of art

as weighed against their condition and state. The team developed a plan that assured a constant exchange between the conservators at The J. Paul Getty Museum, scientists at The Getty Conservation Institute, and staff members at Yale. The collaborating conservators also agreed to spend time in each other's conservation studios in order to discuss and evaluate each treatment in process, with the group of engaged art historians and curators. The goal of this project was to consider carefully the conservation history and condition of each artwork on a case-by-case basis to produce optimal approaches to each new restoration. Supported by a major grant from The Samuel H. Kress Foundation, conservation treatments began in 1998. Since that time twenty-four of Yale's Italian paintings have been restored, with several other treatments currently underway. The success of the project became visible to the public in September 1999 when the Gallery completed a major reinstallation of the early Italian galleries.

In studying the fragments by Fra Angelico, Kanter combined connoisseurship and art historical knowledge first to propose that the master rather than a shop assistant or follower painted the Yale panels, and then to suggest their relationship to the Getty panels, which was subsequently confirmed by scientific analysis. In his essay in this catalogue, "An Annunciation by Fra Angelico," Kanter reports on the fascinating technical data gained from visual observation and x-radiography. He also details how the Yale fragments originally served as pinnacles, or tops, of the two wings from a folding tabernacle triptych. These two wings would have folded shut (like cabinet doors) over a central image, which is currently unknown.

Looking beyond either the technical analyses or the aesthetics of the four Fra Angelico panels, we see that their importance also lies in what they can tell us about history. One example of this is outlined in the catalogue essay "Carpentry and Connoisseurship: The Disassembly of Altarpieces and the Rise in Interest in Early Italian Art" by Carl Brandon Strehlke, Adjunct Curator of the John G. Johnson Collection at the Philadelphia Museum of Art. The scholarship of Strehlke, a key consultant to the Gallery and in the Yale/Getty collaboration, complements Kanter's close study of the four specific objects in the exhibition. He discusses fragmentation and the increased interest that arose in collecting early Italian art as the result of changes of taste from the Renaissance through the nineteenth century. He also reveals how we owe a great debt for our current understanding of the art of the early Renaissance to the revival of the study of the period in the eighteenth century.

The claim, then, to a "rediscovery" of an already well-known artist like Fra Angelico is grounded on two levels: the establishment of the relationship of these works for the first time and the firm attribution by Kanter of the Yale paintings to the master himself. Through piecing together these objects, not only is their maker

and his culture more clearly visible but we are reminded that our view of history is in a constant state of flux as it depends upon fragments of information, which grow and change accordingly with developments in the field.

We are grateful for the opportunity to present the scholarship and conservation efforts that sparked this exhibition and catalogue. First and foremost, we would like to thank The Samuel H. Kress Foundation for its vital support of this publication and exhibition, with additional support from the Robert Lehman Exhibition and Publication Fund as well as Mr. Lionel Goldfrank III, B.A. 1965. We also thank Kathleen Derringer, Associate Director of the Yale University Art Gallery, who helped coordinate the funding support for this project. The exhibition never would have come to fruition without the willing cooperation of The J. Paul Getty Museum, whose former director John Walsh and current director Deborah Gribbon have supported the Yale/Getty conservation collaboration in all stages of its development. From the Getty, Mark Leonard, Conservator of Paintings, and Scott Schaefer, Curator of Paintings, proved invaluably helpful and were eager to realize this joint effort. Getty paintings conservator Elisabeth Mention was very helpful in guiding the way the panels are presented, as was Andrea Rothe, who performed some of the conservation work on the Yale Fra Angelico panels. Gene Karraker and Giovanni Marussich both assisted Andrea Rothe in structural work to the panels, and Mike Mitchell and Marvin Green constructed the mount.

Many staff members at the Yale University Art Gallery were also crucial to the project stewardship. Mark Aronson, Chief Conservator, and Patricia Garland, Senior Conservator, assisted Kanter in the initial stages of his research and should be lauded for their sustained commitment to the conservation project. Of the Department of European and Contemporary Art, we are very grateful to Joanna Weber, Assistant Curator, who has provided continuous attention and oversight in Yale's Italian paintings collection in recent years, as well as to Jennifer Gross, the Gallery's new Seymour H. Knox, Jr., Curator of European and Contemporary Art. The Department's Administrative Assistant, Yvonne Morant, has overseen the smooth flow of logistics, while Yale senior Candice LeDuff, B.A. 2001, assisted in acquiring photographs for the catalogue. As always, we are beholden to Burrus Harlow and the members of our expert installations department, who have deftly executed this intimate and jewel-like exhibition.

We also give thanks to Jeffrey Schier, Senior Editor of Yale University Press, Elise Kenney, Archivist of the Yale University Art Gallery, and especially James Mooney

for their careful editing. We were fortunate to work with Howard Gralla, who is responsible for this catalogue's beautiful design.

The genesis of this project lay in the dedicated research and visual acuity of Laurence B. Kanter, to whom the field is indebted both for his broad scholarship and his particular interest over the years in Yale's early Italian pictures. The spirit of collegiality that has guided fruitful work between scholars, curators, conservators, scientists, students, and others, will hopefully stimulate other far-reaching partnerships in the fields of art and art history.

Jock Reynolds
The Henry J. Heinz II Director

Clay Dean
Exhibition and Catalogue Organizer
Research Associate
Department of European and Contemporary Art

REDISCOVERING FRA ANGELICO

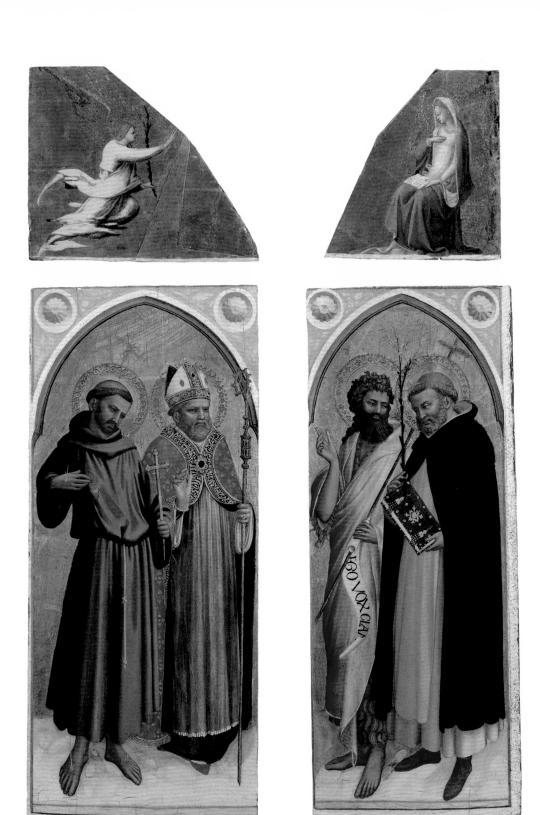

Plate 1 Image showing the reunited panels. Above: Fra Angelico, *Annunciation*. Yale University Art Gallery, New Haven. Gift of Hannah D. and Louis M. Rabinowitz. Below: Fra Angelico, *Saint Francis and a Bishop Saint* (left wing) and *Saints John the Baptist and Dominic* (right wing). The J. Paul Getty Museum, Los Angeles.

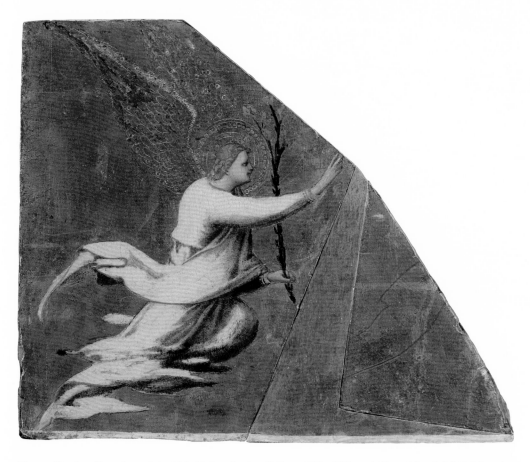

Plate 2 Fra Angelico, *Annunciation.* Yale University Art Gallery. Gift of Hannah D. and Louis M. Rabinowitz.

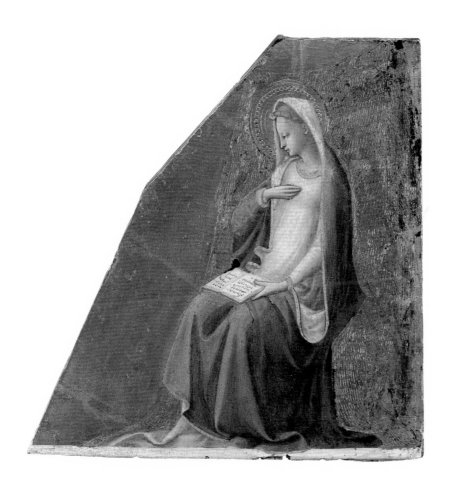

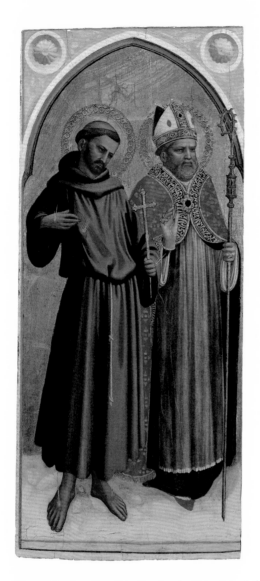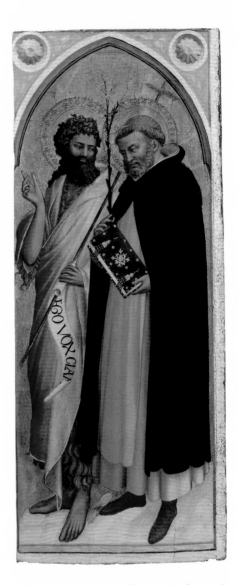

Plate 3 Fra Angelico, *Saint Francis and a Bishop Saint* (left wing) and *Saints John the Baptist and Dominic* (right wing). The J. Paul Getty Museum.

AN ANNUNCIATION BY FRA ANGELICO

Laurence B. Kanter

Among the treasures that have long lain in study storage at the Yale University Art Gallery are two small, irregularly shaped panels representing the Annunciatory Angel and the Virgin of the Annunciation (Plate 2), a gift to the University with the Hannah D. and Louis M. Rabinowitz Collection in 1959.[1] One of these two panels portrays the Virgin seated in profile to the left, wearing a red dress covered by a blue cloak with yellow lining. She touches her breast with her right hand in a gesture of modesty and nods her head slightly to signify her humility in receiving the angelic message of grace. Her left hand holds a small book open across her knees, its red leather binding and two leather straps with brass clasps depicted with astonishing precision. Her seat is indicated, or rather suggested, with consummate subtlety by the gilt cloth of honor that envelopes it, modeled exclusively by burin hatchings in the gold ground of the panel reinforced by translucent red glazes, a technical and decorative tour de force that by itself reveals the mind and hand of a great master. The same technique is employed to represent the wings of the angel Gabriel, in the companion panel, who flies toward the Virgin at the right, his right hand extended in a gesture of benediction, his left grasping a stalk of lilies. The rose-violet robes of the angel billow out behind him, emphasizing the energy of his forward movement, but somewhat confusingly they blend below his waist with the clouds upon which he kneels: an unfortunate result of the aging of pigments and glazes that lends this figure the anachronistic aspect of a vorticist sculpture.

Only recently has it been possible to speak of these two remarkable panels as a pair, for as long as they have been in the collection of the Yale University Art Gallery, and presumably since before their recorded collecting history commenced in the nineteenth century,[2] they were not two but one panel, artificially combined with a third gilded fragment to compose a single rectangular composition (Figure 1), intended to permit them to masquerade as a complete and independent work of art. Lionello Venturi[3] and Charles Seymour, Jr., both recognized them as having originally functioned as pinnacles to the wings or shutters of a portable triptych, a function that also explains their relative thinness, ranging from 1.7 to 1.9 cm., and their backs painted fictive porphyry, with fragmentary borders of white describing partial arcs along their inner edges and straight moldings along their outer edges (Figure 2).

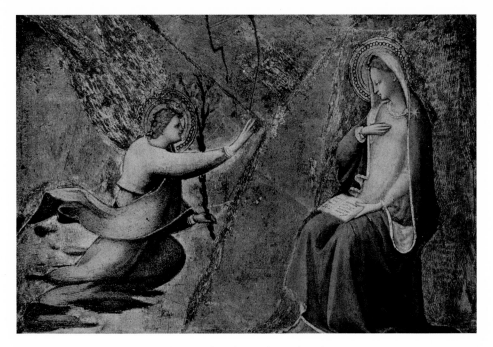

Figure 1 Photograph from 1959 showing the Yale panels combined.

Their irregular shape today is the result of cutting to accommodate their assemblage into a rectangular format; originally they were each half arches, the left pinnacle wider than the right by some 2 or 3 cm.[4] Such a discrepancy is unusual but not unprecedented among surviving Renaissance tabernacles, where the two folding wings do not always meet over the exact center of the central panel.

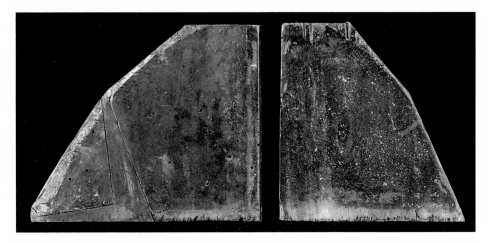

Figure 2 Reverses of the Yale panels.

In cataloguing these panels for the Art Gallery, Seymour recognized their intimate connection to the style of Fra Angelico, but was unable to persuade himself that the connection was sufficiently close to warrant an attribution directly to that greatest of Florentine painters. At first,[5] he compared them to the works then grouped around the Griggs *Crucifixion* in the Metropolitan Museum of Art, New York (Figure 3), a group that has since come to be identified with the artist Giovanni Toscani, although the Griggs *Crucifixion* itself has been correctly recognized as one of Fra Angelico's earliest masterpieces.[6] Upon subsequent reconsideration,[7] he noted that "the influence of Fra Angelico . . . appears stronger than it did [that is, when he first catalogued it]. In type and drapery style, particularly that of the Virgin, the artist seems to be closest to the assistant of Fra Angelico responsible for the Prado *Annunciation* predella." The Prado *Annunciation* (Figure 9) was, in Seymour's time, frequently and authoritatively dismissed as a derivative effort, a later imitation of Angelico's famous Annunciation altarpiece in Cortona, whereas it is now generally acknowledged to precede the Cortona altarpiece and to be another early masterpiece by Fra Angelico.[8] Even Venturi, the first modern scholar to catalogue the Yale (then Rabinowitz) panels, drew attention to the resemblance between the Virgin and the same figure in the famous tondo of the Adoration of the Magi from the Cook Collection (now in the National Gallery of Art, Washington), a figure he took to be painted by Filippo Lippi but that is now almost universally recognized as the contribution of Fra Angelico to this magisterial work.[9]

Scholars working in the 1950s and 1960s knew Fra Angelico as a different artist than he appears today, and it is not surprising that, in considering the Yale *Annunciation*, Seymour could stray so often so close to Angelico without realizing that he was, in fact, discussing works by the master himself. The first scholar to tie together the loosely related threads of observation and to propose an attribution directly to Fra Angelico for the Yale *Annunciation* was Miklós Boskovits.[10] In the course of his reconstruction of Angelico's youthful activity, Boskovits introduced two other small narrative panels — a *Nativity* in the Minneapolis Museum and a *Coronation of the Virgin* in the Cleveland Museum of Art — stylistically related to the Yale pinnacles and, like them, attributable to Angelico. Specifically, he proposed that the Minneapolis *Nativity* might have been a fragment from the same triptych as the Yale panels, standing in the wing beneath one of them.[11] Though the proposal was reasonable on stylistic grounds, it was physically implausible, since the *Nativity* in Minneapolis is only 17.5 cm. wide, considerably less than either the *Annunciatory Angel* or the *Virgin Annunciate* in New Haven.

It is now possible to identify with certainty the panels that originally stood beneath the Yale pinnacles and comprised with them the wings of a triptych.

Figure 3 Fra Angelico, Griggs *Crucifixion*. The Metropolitan Museum of Art, New York.

Figure 4 Reverses of the Getty panels.

Recently acquired by The J. Paul Getty Museum in Los Angeles, each represents two standing saints within a framing arch: Saints John the Baptist and Dominic in the right wing, and Saint Francis and a Bishop Saint (Plate 3) in the left wing.[12] The Getty panels, as is to be expected, share many physical peculiarities with the Yale pinnacles. The right panel, originally standing beneath the Yale Virgin, is 21.2 cm. wide, 2 cm. less than the left panel (23.2 cm.). Both panels are approximately 1.7 cm. thick, and both are painted on the verso (Figure 4) with fictive porphyry and a white surround, the same white and the same porphyry (including speckled effects from

21

shaking over them a brush wet with glaze pigments) as on the New Haven panels. The only impediment to what at first seems an obvious reconstruction is the fact that the four saints in the Getty panels are lit decisively from the right, while the light in the Yale panels is cast from the left. It is difficult to accuse any artist of a solecism of this sort, let alone an artist of such towering genius and penchant for naturalistic observation as Fra Angelico, but such, in fact, seems to have been the case. X-radiographs of the Getty and New Haven panels (Figure 5) reveal that the wood grain is continuous between them, establishing beyond a shadow of a doubt that they were painted on the same panels and sawn apart only in relatively modern times.

What are the characteristics of style of the Yale and Getty panels that permit them to be attributed to Fra Angelico and that may assist in determining their date? In the first instance, of course, their quality of observation is unmistakably more sophisticated than that of any other Florentine painter of the period. In particular the figures' draperies are studied with an uncommon sensitivity to texture and weight and are painted with a unique technical command of the means necessary to communicate their tactility to the viewer. The gauzy weightlessness of the Bishop Saint's linen surplice — rendered with flickering sheens of highlight rustling along its surface — contrasts with the stiff, cumbersome velvet or brocaded silk of his cope, and both throw into sharp relief the coarse brown sackcloth of Saint Francis's rumpled habit. The folds of the Virgin's blue mantle fall in slow, elegant loops and break in thick pleats along the floor, all studied from the effects of real cloth, as must have been the almost miraculous rendering of the cloth-of-gold behind her. A signature device of Fra Angelico is his tendency to introduce gratuitous curling folds to the edges or hems of draperies to enable them to catch glancing highlights from a raking light source, enhancing the impression of their plasticity. Such, for example, is the trailing end of Saint John the Baptist's salmon-colored cloak, where it falls in front of his right foot, or the near edge of Saint Dominic's scapular immediately below the book he clasps in his left hand. Saint Dominic's and Saint Francis's habits are, in effect, as much studies in empirical perspective as they are of the behavior of cloth, as the vertical pleats and folds in which they fall define the space around the figures' bodies like the flutes of a classical Roman column.

The types and attitudes of the figures in these panels are also fully consonant with those in other widely accepted works by Fra Angelico. The closest analogies, both for scale and probable date of execution, are to be found in the illuminations to a Gradual painted for San Domenico, Fiesole, now in the Museo di San Marco, Florence (MS. 558).[13] Particularly close to the profiles in the Yale pinnacles are the angels surrounding Saint Dominic in Glory (Figure 6) on fol. 67v., or the Angel of the Annunciation (Figure 7) on fol. 33v. of the Gradual. All these in turn, as well as

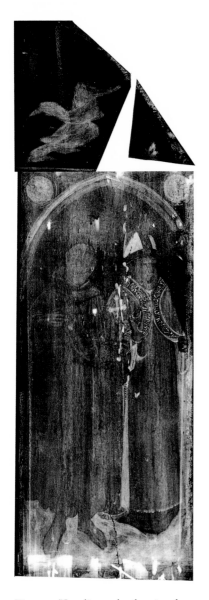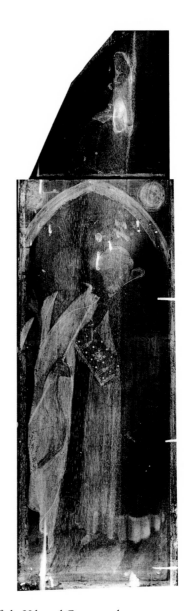

Figure 5 X-radiographs showing the matching woodgrain of the Yale and Getty panels.

the saints in the Getty panels, find telling parallels in the almost certainly contemporary *Last Judgment* from Santa Maria degli Angeli[14] or the San Pietro Martire triptych (Figure 8), both also in the Museo di San Marco. The latter also provides an exact precedent for certain awkward passages in the Getty panels, such as the tilted projection of their marbleized pavements and the "Gothic" rendering of Saint Francis's or Saint John the Baptist's feet, oversized and oriented too nearly parallel to the picture plane.

Figure 6 Fra Angelico, Saint Dominic in Glory, MS. 558, fol. 67v. Museo di San Marco, Florence.

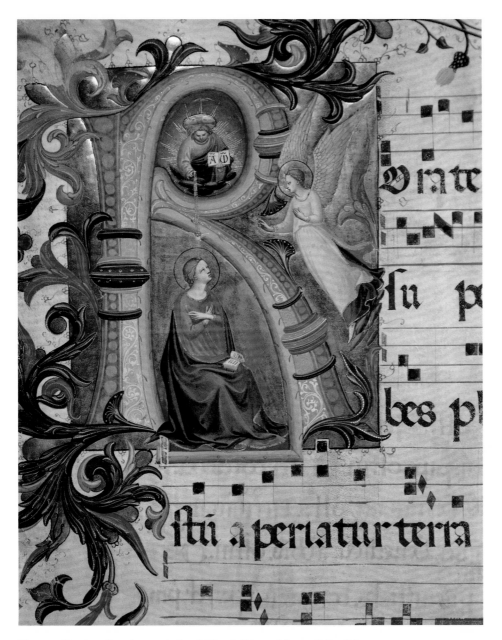

Figure 7 Fra Angelico, Annunciation, MS. 558, fol. 33v. Museo di San Marco.

The figures in the Getty and Yale panels are more finely ideated and painted than those in the San Pietro Martire triptych; whether because of their more intimate scale or because they were, in fact, painted marginally later is an open question. The precision of the architectural decoration of the niches surrounding the Getty saints, with ogival moldings carefully drawn and shaded and elaborately carved oculi filling their spandrels, recalls the mastery of similar details in the Prado *Annunciation* altarpiece (Figure 9), the work in which Fra Angelico first demonstrates his thorough command of Masaccio's principles of spatial illusion. That they are unlikely to be as advanced as this work, however, is indicated by a singular "error" of spatial logic evident in the right-hand panel at the Getty. Here Saint John the Baptist calls Saint Dominic's attention to the subject of the missing central panel of the triptych. The Baptist stands closer to the center and notionally behind Saint Dominic, yet his foot reaches in front of Saint Dominic's all the way to the front lip of the pavement.

Dating Fra Angelico's paintings in this early part of his career, the decade of the 1420s, is at best a relative task, since no firmly documented commissions establish fixed chronological points or standards of comparison. Traditional scholarship addressing the question of Angelico's early works was dependent on the scanty information drawn from Vasari's enthusiastic but factually unreliable biography and from sixteenth- and seventeenth-century homiletic sources, from which it was adduced that the artist was born in 1387 and entered the Dominican order in 1407.[15] This left more than two full decades of undocumented "early career" before the appearance in 1429 of the first secure notice of payment to Fra Angelico for a surviving work of art. It made him a contemporary of Masolino and situated him firmly in the late Gothic world of Gherardo Starnina and Lorenzo Monaco. By implication it also made him a late convert to the progressive Renaissance style of Masaccio and Brunelleschi, a follower rather than a leader in this regard. All references to Angelico's early career published prior to 1955 must be understood with this image of the artist in mind. In 1955, the Dominican scholar Stefano Orlandi argued that Angelico was more likely to have been born around 1400 and to have entered the Dominican order only after the convent of San Domenico in Fiesole was rebuilt in 1418,[16] while Werner Cohn presented evidence that as late as 1417, the first recorded notice of him, Angelico had not yet professed vows.[17] The documentary window of opportunity for Angelico's entry to the convent of San Domenico, Fiesole, has now been narrowed to the years between 1419 and 1423;[18] his conjectural birth date, following Orlandi's suggestion, has been slipped forward a decade or more, to the years between 1395 and 1400; and the trajectory of his development compressed into a more manageable time frame, one dominated only initially by the colorful lyricism and compositional ingenuity of Lorenzo Monaco, but subse-

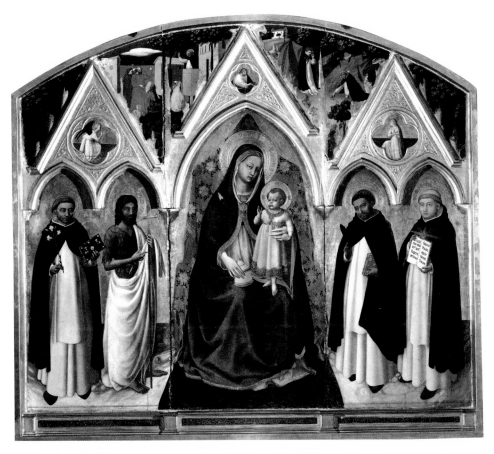

Figure 8 Fra Angelico, *San Pietro Martire Triptych.* Museo di San Marco.

quently and with far greater consequence by the illusionistic innovations of Gentile da Fabriano and Masaccio.

The point of departure for study of Angelico's early career, no matter how many decades it was thought to encompass, has always been the record of a payment of ten Florins in 1429 to the monastery of San Domenico in Fiesole on behalf of the nuns at San Pietro Martire, a payment presumably associable with the triptych (Figure 8) that formerly stood on the high altar of that church.[19] How long before this date the painting may have been completed and delivered is a matter of debate, but the recent discovery of another document from the same year, relating to an altarpiece for the confraternity of Saint Francis in Santa Croce (which presumably was by then complete),[20] as well as the fact that the great Strozzi *Deposition* from Santa Trinita is now known to have been completed and installed by 1432,[21] suggests that the San Pietro Martire triptych must already by that time have been more than a few years old. A conceptual gulf lies between it and the Strozzi *Deposition* that can

27

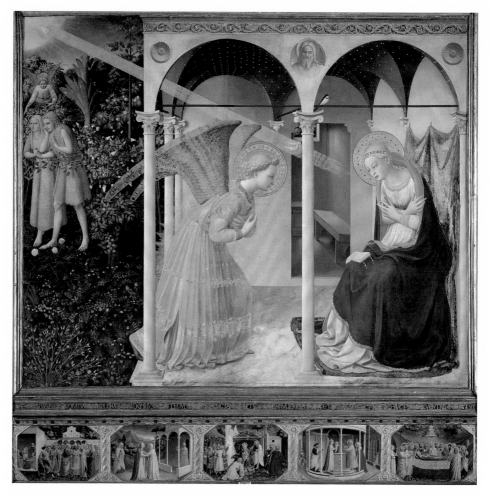

Figure 9 Fra Angelico, *Annunciation* Altarpiece. Museo Nacional del Prado, Madrid.

only be explained by the lapse of a significant amount of time between the completion of one and the design (which clearly must be antedated to 1431 or even 1430) of the other, and the question that must be resolved is how much earlier than 1429 could the San Pietro Martire triptych have been painted.

Assuming that payment followed fairly quickly upon its completion, and therefore that the painting dates to the late 1420s, scholars have generally sought to describe the San Pietro Martire altarpiece as a product of tension between its conventional Gothic form — a gabled triptych with ogival framing arches and a gold ground, the Virgin and Child filling the center panel and two saints standing frontally in each lateral — and the artist's awareness of Masaccio's revolutionary pictorial innovations. It has recently been pointed out, however, that the Masaccio

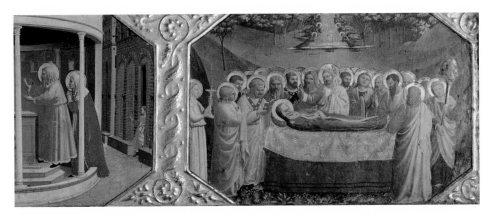

Figure 10 Detail of Figure 9.

with whom Angelico appears to be familiar in this painting is the Masaccio of the *Sant'Anna Meterza* altarpiece and of no later moment, and that there is no reason the triptych could not have been painted as early as 1424, not long after the San Domenico, Fiesole, high altarpiece.[22] Indeed, consideration of his immediately subsequent works suggests that 1424 is as much a *terminus a quo* as a *terminus post quem* for execution of the San Pietro Martire triptych, which is unlikely to have been painted after 1425 at the latest.

The first major painting in which Angelico displays an active interest in Masaccesque or Brunelleschian theories of the projection of illusionistic space is the great altarpiece of the Annunciation in the Museo del Prado in Madrid (Figure 9), painted for an altar in the rood screen of the convent church of San Domenico, Fiesole, probably around 1425 or at the latest 1426, roughly contemporary to Masaccio's work in the Brancacci Chapel. Few paintings in his entire oeuvre have been subject to as much vacillation of critical opinion as this one, with proposals for its date ranging from 1425 to 1445 and the preponderance of attributions assigning it to the master's workshop. The simple, single-point perspective of its predella narratives (Figure 10) and the teeming abundance of almost microscopic detail compressed into the landscape of its main scene are usually taken as evidence of an imitative talent employing Angelico's vocabulary without fully comprehending its import. But that this is, in fact, a precocious masterpiece by Angelico himself should be self-evident. The believably realistic textures of Adam's and Eve's hair coats in the left middle distance, the complicated but mathematically coherent recession of painted gold dots on the delicately shaded blue sail vaults of the loggia, and the utterly convincing fall of the hem of the Virgin's dress on the floor about her feet are dependable indicators of Angelico's authorship. Still others are barome-

ters of the remarkable caliber of his intelligence, such as the amazing intricacy with which he painted the delicate glazing of the feathers in the angel's wings or the gilt embroidery on his robe, carefully distorted along the crease of each pleat as the angelic messenger begins his genuflection. Even more remarkable is the incomparable subtlety of reflected highlights cast upon the floor and back wall where they are visible between the feet of a simple wooden bench in the small chamber behind the Virgin.

The scenes from the life of the Virgin painted in the predella to the Prado *Annunciation* (Figure 10) are no less impressive in their attention to veristic detail, but compared to Angelico's later works, their treatment of space is relatively simple, almost Albertian "before the letter" rather than Brunelleschian. His figures, furthermore, while animated by a stimulating variety of pose, attitude, and expression, are still grouped in compact, isocephalic knots arranged, with few exceptions, parallel to the picture plane. In the scene of the Dormition of the Virgin, for example, twenty-one figures are tightly grouped around and behind the Virgin's bier, each in a different attitude of song or prayer but none breaking the closely serried ranks that lend an almost military appearance to their assembly. A very slightly later version of this composition is found in a predella panel in the John G. Johnson Collection at the Philadelphia Museum of Art,[23] also portraying the Dormition of the Virgin, more specifically the moment of her entombment (Figure 11). In this painting of about 1426 or 1427, the Virgin's bier and catafalque have been replaced by a carved marble sarcophagus, permitting the artist to display his by-now-complete mastery of the principles of centralized, single-point perspective. The narrative structure is also more ambitious, focusing on the bending apostles, five in number, who are shown at the moment of lowering the Virgin's body on its winding sheet into her tomb, the cloth pulled tight across their knuckles by her weight. Landscape elements in this panel are still generically Ghibertian, and space, other than the volume of it displaced by the tomb itself, is primarily indicated by the recession of the congregating apostles in groups of three, their heads diminishing in size and progressing upward on the panel as they stand farther away from the picture plane.

A further refinement in this direction is represented by a predella panel now in Berlin showing the Death of Saint Francis (Figure 12), probably painted in 1427 or 1428 but in all events not later than 1429.[24] Here Angelico conceived a still more ambitious and complicated narrative and posed his figures with greater torsion and movement backward and forward in space, though the architecture behind them has been reduced to a nearly emblematic suggestion of setting. By about 1430, the approximate date of a reliquary panel from Santa Maria Novella portraying the Dormition and Assumption of the Virgin (Figure 13), now in the Isabella Stewart Gardner Museum, Boston,[25] Angelico demonstrated both his total mastery of

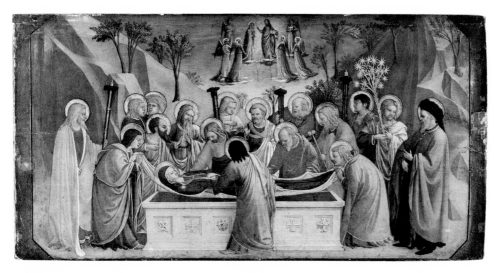

Figure 11 Fra Angelico, *Dormition of the Virgin*, with mid eighteenth-century restorations by Ignazio Hugford. John G. Johnson Collection, Philadelphia Museum of Art.

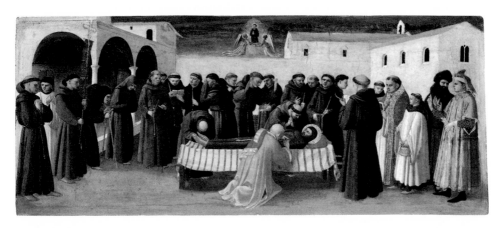

Figure 12 Fra Angelico, *Death of Saint Francis*. Staatliche Museen zu Berlin, Preußischer Kulturbesitz, Gemäldegalerie.

Brunelleschi's system for the construction of illusionistic space and his relative unconcern for its rigorous method and mathematical principles. The illusion that he wishes instead to convey is that of the details of nature and of human behavior that make his paintings such effective vehicles for psychological and spiritual dialogue. In the lower scene of the Gardner *Dormition and Assumption of the Virgin*, fifteen male figures painted on a miniaturist scale are each fully individualized and unmistakable for any other. The Virgin's bier is covered by a cloth of honor the form of which is painstakingly engraved in the gold ground of the panel and modeled in translucent

31

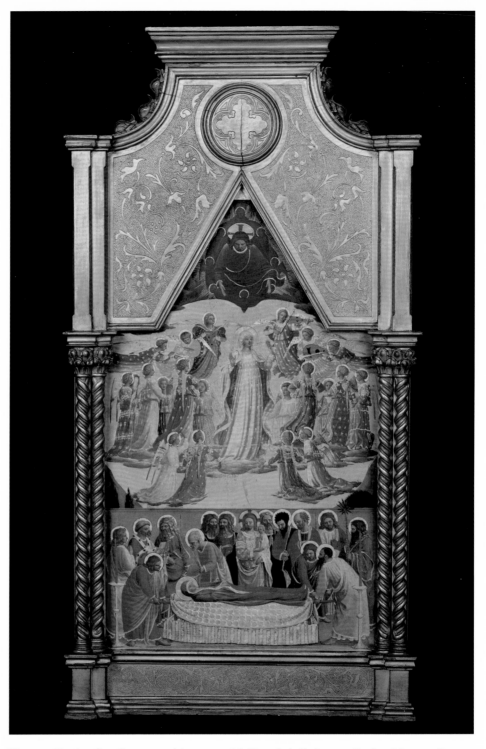

Figure 13 Fra Angelico, *Dormition and Assumption of the Virgin.* Isabella Stewart Gardner Museum, Boston.

glazes to indicate the pull of a heavy fabric draped over the carrier poles and lightly depressed by the ethereal but nonetheless human weight of the Virgin's body. Three apostles bend to lift the bier, their feet spread and planted firmly on the ground to brace themselves, while a fourth apostle, pulling back his cloak to free his arm for the task, hurries to reach for the unmanned fourth pole, lest the holy Virgin be indecorously tilted while being transported to her sepulcher. This is a detail of supremely human intimacy, underscored by the gesture of the bending apostle at the right who points to inquire why no one has taken up the burden of the fourth pole. At this point in his career, Angelico is no longer experimenting with any systems or techniques, but is deploying all he has learned in the service of his profoundly intellectual talent.

This sequence of works chronicling Angelico's development in mastering the techniques of pictorial illusion — a remarkably accelerated trajectory that is itself an indication of the depth of his sensibilities — leaves little room for such germinal masterpieces as the San Pietro Martire triptych or Missal 558 at the Museo di San Marco to have been painted anytime after 1425. Correctly dating them and the almost certainly contemporary Yale/Getty triptych wings to the very end of, though still within, the first quarter of the fifteenth century establishes them among the most sophisticated and precocious accomplishments of Florentine painting before Masaccio permanently altered the course of artistic development in that city.

POSTSCRIPT

Further information about the structure of the triptych of which the Yale/Getty wings once formed part is provided by v-shaped marks or channels visible on the backs of the Getty panels along their vertical edges (Figure 4). These marks, stained black by long contact with oxidizing iron, result from the removal of hinges, which on early Renaissance triptychs were usually formed of wire loops driven at an angle, from the front toward the back, through the sides of the panel. The open ends of the loop protruding through the back were then spread to a "v" shape to secure them in place, and hammered flush to the panel surface, at which point they could be gessoed over and painted to mask their presence. Removal of the hinges from the Getty panels exposed the channels created by the hammering of the ends of the wire loops into the panel. These channels converge at 6.7 cm. (right) and 8.9 cm. (left) from the top and less than 1 cm. from the bottom edges of each panel, and indicate that the panels must have been trimmed at the bottom: hinges driven into the wood this close to the bottom edge would have split the panels. Indeed, in their present

state, the wire ends of the hinges would actually have projected beneath the bottoms of the panels. It is reasonable to assume that at least 5 cm. of wood, probably more, are missing from the bottom of each panel, and that these missing segments were most likely painted with tituli identifying the saints standing in the niches above. Allowing, then, for the losses at the bottom of each panel, for the completion of the truncated arches at the top of the New Haven pinnacles, and for some small amount of wood lost when these were sawn away from the Getty panels, the total original height of each of the wings of this triptych was not less than 80 cm. and probably slightly more. This dimension, coupled with their combined width of approximately 45 cm.,[26] indicates the size of the central panel of the triptych over which the Yale/Getty wings would have folded neatly when the triptych was closed.

Identifying this central panel is a less easy task than reconstructing the wings. Its subject is, of course, not certain. Triptychs such as this, especially with standing saints in the wings, commonly featured a Virgin and Child in the central panel, but images of the Crucifixion or other narratives from the life of Christ would be equally plausible candidates. Additionally, there is no certitude that the central panel was painted — the wings may have been intended to fold closed over a reliquary or a tabernacle containing a sculpted figure — nor that if it was painted it necessarily survives today. As it happens, only one surviving panel by Fra Angelico does conform even approximately to the dimensions required of the central panel of this complex, but this panel is preserved in such a poor state that any physical evidence of its possible association with the Getty and Yale panels, such as hinges at corresponding heights along its outer edges, has been lost. The panel in question is a *Madonna of Humility* (Figure 14) from the Andrew W. Mellon Collection, now in the National Gallery of Art in Washington.[27] Severely damaged and extensively repainted, it measures 61 × 45.5 cm., but as its composition makes clear, it has been trimmed substantially in height. The cloth of honor behind the Virgin, which truncates at the top edge of the panel, must originally have continued upward, terminating in a point or possibly in the hands of a third angel. Based on the proportions of Fra Angelico's other known paintings of analogous subjects, Miklós Boskovits[28] has estimated the original height of this panel to have been slightly less than twice its width, therefore between 80 and 90 cm.

The fact that the Washington *Madonna of Humility* is the one surviving work by Angelico of the requisite size is of suggestive but limited value as a basis for reconstruction. Its repainted condition makes judgments of its style and date, the only remaining evidence by which it could be associated with the Yale/Getty wings, precarious, and the problem must for the moment be left unresolved. Equally problematic is Seymour's suggestion[29] that a *"Christ with a Crown"* (actually Christ with a

Figure 14 Fra Angelico, *The Madonna of Humility*. Andrew W. Mellon Collection, National Gallery of Art, Washington. © 2001 Board of Trustees, National Gallery of Art, Washington.

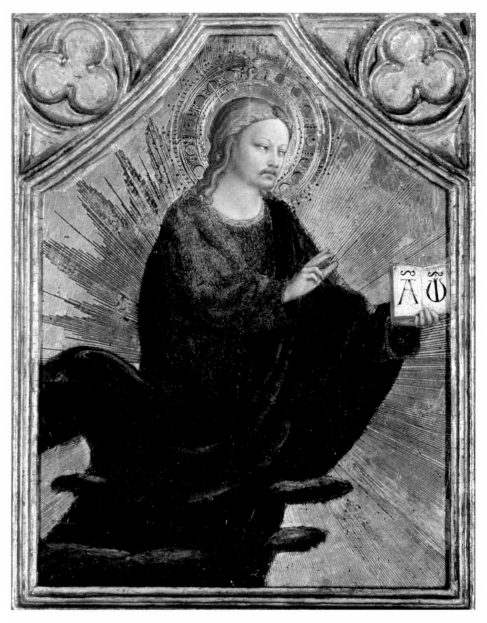

Figure 15 Fra Angelico, *Christ Blessing*. The Royal Collection © 2001, Her Majesty Queen Elizabeth II.

book) in Hampton Court, now on loan to the National Gallery, London (Figure 15), might have formed part of a complex with the Yale *Annunciation*. The Hampton Court panel[30] must indeed have completed an Annunciation group, but whether with the Yale pinnacles or with others similar to them is uncertain. Originally it would have filled the pinnacle of the central panel of a triptych: the outer profile of

the panel is typical of the central gables in a number of Fra Angelico's altarpieces from the early part of his career. It is interesting to note a nearly identical image of Christ delivering the gift of the Holy Spirit to the Virgin in the Annunciation scene on fol. 33v. of the Museo di San Marco Gradual (Figure 7), a work that must be almost exactly contemporary to the Yale *Annunciation*.[31]

NOTES

1. 1959.15.6; Charles Seymour, Jr., *Early Italian Paintings in the Yale University Art Gallery*, New Haven, 1970, no. 91, pp. 132–34.

2. The panels are noted in the collection of Sir Charles Townley, England, in 1877, and are said to have been in the Albertini collection, Pistoia, prior to that.

3. Lionello Venturi, *The Rabinowitz Collection*, New York, 1945, pp. 15–16.

4. The maximum width of the *Virgin* is presently 18.1 cm., but the fragmentary state of the painted white border on its reverse indicates that it was trimmed at the right and, more substantially, at the left, possibly resulting in an original width of 20 cm. or slightly more. The *Annunciatory Angel* was cut more dramatically, but an approximate reconstruction of it with the unpainted gilt fragment apparently removed from the same pinnacle (the painted arch along their borders is continuous) results in a panel originally about 23 cm. wide.

5. Charles Seymour, Jr., *The Rabinowitz Collection of European Paintings*, New Haven, 1961, p. 19.

6. Richard Offner, "The Mostra del Tesoro di Firenze Sacra — II," *Burlington Magazine*, LXIII, 1933, pp. 167, 170–73; Luciano Bellosi, "Il Maestro della Crocifissione Griggs: Giovanni Toscani," *Paragone*, CXCIII, 1966, pp. 44–58; M. Eisenberg, "'The Penitent St. Jerome' by Giovanni Toscani," *Burlington Magazine*, CXVIII, 1976, pp. 275–83. Luciano Bellosi, in *Arte in Lombardia tra Gotico e Rinascimento*, Milan, 1988, p. 196, proposed removing the Griggs *Crucifixion* from Offner's group and reassigning it to Fra Angelico as an early work, and it was exhibited as such in New York in 1994 (Carl Brandon Strehlke in *Painting and Illumination in Early Renaissance Florence, 1300–1450*, New York, 1994, pp. 324–26). Strehlke (followed by Giorgio Bonsanti, *Beato Angelico: Catalogo completo*, Florence, 1998, pp. 115–16) dates the Griggs *Crucifixion* ca. 1423 on the basis of supposed derivations from Gentile da Fabriano's *Adoration of the Magi* altarpiece painted for Palla Strozzi. None of the figural motifs in question are necessarily derivative, however, and a more plausible chronology for Angelico places this painting in the period ca. 1418–20. At that date it is also unnecessary to explain the apparent differences in handling between the foreground and background figures as either the intervention of a second artist (Bonsanti) or dependence on a different prototype, possibly one by Arcangelo di Cola (Strehlke). Angelico's exactly contemporary (i.e., ca. 1418–20) *Virgin and Child* in the Boymans van Beuningen Museum, Rotterdam (Bonsanti, *Beato Angelico*, pp. 25, 118), as well as the slightly later (ca. 1420) *Thebaid* in the Uffizi (Ibid., p. 113), employ the same range of technical and expressive devices as the Griggs *Crucifixion*. Miklós Boskovits ("Un'adorazione dei Magi e gli inizi dell'Angelico," reprinted in *Immagini da Meditare*, Milan, 1994, pp. 365–68) accepts the Griggs *Crucifixion* as a work by Angelico painted before 1420. Another, little-known painting by Angelico of the same date in the Richard L. Feigen collection, New York (R. Feigen, *Tales from the Art Crypt*, New York, 2000, pp. 10–11), represents the fragmentary head either of Joseph (from an Adoration) or Joseph of Arimathea (from a Deposition or Lamentation).

7. Seymour, *Early Italian Paintings*.

8. J. Pope-Hennessy, *Fra Angelico*, 2nd ed., London, 1974, p. 194; Licia Collobi-Ragghianti, "Zanobi Strozzi," *Critica d'arte*, XXXII, 1950, p. 458; Miklós Boskovits, *Un'adorazione dei Magi e gli inizi dell'Angelico*, Bern, 1976, pp. 28–30, as second half of the 1420s; Strehlke, *Painting and Illumination*, p. 34; Idem., *Angelico*, Milan, 1998, pp. 21–23, as ca. 1426–27.

9. Fern Rusk Shapley, *Paintings from the Samuel H. Kress Collection, Italian Schools XIII–XV Century*, London, 1966, pp. 95–97; Jeffrey Ruda, "The National Gallery Tondo of the Adoration of the Magi and the Early Style of Filippo Lippi," *Studies in the History of Art*, VII, 1975, pp. 7–39; Miklós Boskovits, "Attorno al Tondo Cook: precisazioni sul Beato Angelico, su Filippo Lippi e altri," *Mitteilungen des Kunsthistorischen Institutes im Florenz*, XXXIX, 1995, pp. 32–67. Luciano Bellosi (in *Pittura di Luce, Giovanni di Francesco e l'arte fiorentina di meta Quattrocento*, Milan, 1990, pp. 43–45) attributes, probably correctly, those portions of the Cook Tondo normally recognized as the contribution of Fra Angelico to Benozzo Gozzoli.

10. Boskovits, *Un'adorazione*, p. 38.

11. Ibid., p. 41.

12. Ironically, these panels were also first published with an attribution to Angelico by Boskovits ("La fase tarda del Beato Angelico: una proposta di interpretazione," *Arte cristiana*, LXXI, 1983, pp. 11–23), but he knew them at a later moment than his initial Angelico studies, and never drew the physical connection between them and the Yale pinnacles.

13. Luciano Berti, "Miniature dell'Angelico (e altro)," *Acropoli*, II, no. 4, 1962, pp. 277–308; 3, no. 1, 1963, pp. 1–38; Strehlke, *Painting and Illumination*, pp. 332–39.

14. Described in Santa Maria degli Angeli in 1568 by Vasari (Giorgio Vasari, *Le vite de' più eccellenti pittori scultori ed archittetori*, ed. Gaetano Milanesi, II, Florence, 1878, pp. 514–15), this painting was identified by Vincenzo Marchese (*Memorie dei più insigni pittori, scultori e architetti domenicani*, I, Florence, 1845, p. 279) as the back or spalliera of the priest's throne near the high altar, and this piece of furniture was in turn associated by Stefano Orlandi (Orlandi, O.P., *Beato Angelico*, Florence, 1964, pp. 27–30) with a documented commission of August 1431. A. Santagostino Barbone ("Il Giudizio Universale del Beato Angelico per la chiesa del monastero camaldolese di S. Maria degli Angeli a Firenze," *Memorie domenicane*, n.s. II, 1989, pp. 255–78) convincingly refutes this identification, and it is now correctly recognized that the *Last Judgment* must be a work of the mid-1420s. It is, in fact, possible that it was in the first instance commissioned to Lorenzo Monaco, a member of the Camaldolese community who held a virtual monopoly over commissions from Santa Maria degli Angeli, just before his death in 1424/25, and was only at that point transferred to Fra Angelico for completion. The halo of Christ in judgment at the center of the composition is raised in pastiglia, an archaic device not elsewhere encountered even in Angelico's earliest works, and it is at least worth speculating on the possibility that he did not enjoy an entirely free hand in designing this painting.

15. See, for example, Vasari, *Le vite*, II, pp. 505–34.

16. Stefano Orlandi, O.P., "Beato Angelico — Note cronologiche," *Memorie domenicane*, LXXII, 1955, pp. 3–37; also printed in *Rivista d'arte*, IV, 1954, pp. 161–97.

17. W. Cohn, "Il Beato Angelico e Battista di Biagio Sanguigni," *Rivista d'arte*, V, 1955, pp. 207–21.

18. Strehlke, *Painting and Illumination*, p. 25. For Pope-Hennessy (*Fra Angelico*, p. 5), this window was narrower, spanning the years 1418–21. It is reasonable to advance the earlier year to 1419, but

while it is possible that Angelico had already entered the convent of San Domenico by 1421, the contention is not subject to proof. The artist is first referred to as Fra Giovanni (his secular name was Guido di Pietro) only in 1424.

19. See Pope-Hennessy, *Fra Angelico*, pp. 190–91, for a résumé of the documentation relevant to this altarpiece. In the first edition of his monograph (London, 1952), Pope-Hennessy dated the triptych ca. 1425, revising this date to 1428 in the second edition (London, 1974). The earlier dating is more likely to be correct.

20. J. Henderson and P. Joannides, "A Franciscan Triptych by Fra Angelico," *Arte cristiana*, LXXIX, 1991, pp. 3–6.

21. R. Jones, "Palla Strozzi e la sagrestia di Santa Trinita," *Rivista d'arte*, XXXVII, 1984, p. 38.

22. Strehlke, *Angelico*, p. 11.

23. Carl Brandon Strehlke, "Fra Angelico and Early Florentine Renaissance Painting in the John G. Johnson Collection at the Philadelphia Museum of Art," *Philadelphia Museum of Art Bulletin*, LXXXVIII, 1993, pp. 4–26; Idem., *Painting and Illumination*, pp. 330, 332; Laurence B. Kanter, "A Rediscovered Panel by Fra Angelico," *Paragone*, DXCIX, 2000, pp. 3–13.

24. Henderson, Joannides, "Franciscan Triptych."

25. Strehlke, *Painting and Illumination*, pp. 342–45.

26. Both Getty panels have been trimmed slightly in width. These estimated dimensions do not allow for the possible existence of frame moldings surrounding the panels, which, though rare, are not unknown in early quattrocento triptych wings.

27. Fern Rusk Shapley, *National Gallery of Art: Catalogue of the Italian Paintings*, I, Washington, 1979, pp. 13–14.

28. *Systematic Catalogue of Fifteenth-Century Italian Paintings in the National Gallery of Art*, Washington, forthcoming.

29. Seymour, *Early Italian Paintings*, p. 134.

30. John Shearman, *The Early Italian Pictures in the Collection of Her Majesty the Queen*, Cambridge, 1983, pp. 13–15; Bonsanti, *Beato Angelico*, p. 116.

31. A roundel of the blessing Christ in the Louvre (Diane Cole Ahl, "Il 'Dio Padre' del Beato Angelico al Louvre: annalisi di un opera giovanile," *Antichità viva*, XXIII, 1984, no. 3, pp. 19–20; Bonsanti, *Beato Angelico*, pp. 120–21) obviously fulfilled the same function as the London fragment, though rather than filling the center pinnacle it would have been inset as part of the pastiglia decoration of the frame. Very slightly later in style than the London fragment, the Paris roundel is not entirely convincing as a candidate to have completed the present triptych, though it is a candidate that cannot yet be definitively ruled out.

CARPENTRY AND CONNOISSEURSHIP: THE DISASSEMBLY OF ALTARPIECES AND THE RISE IN INTEREST IN EARLY ITALIAN ART

Carl Brandon Strehlke

Galleries of early Italian art in American and European museums contain mostly fragments. Visitors often do not realize that the painting of a Madonna, saint, or religious story that looks like an independent panel was usually once part of a large altarpiece. Even small pictures like the triptych by Fra Angelico reconstructed in this exhibition were ruthlessly taken apart and the pieces sold separately. But the story of the breakup and dispersal of early Italian art is also intimately connected to its rise in popularity in the late eighteenth century and at the same time the beginning of serious study of the subject.

Imagine a large altarpiece on sawhorses set up in the side chapel of a church after morning Mass with a priest and perhaps a fine arts commissioner, a collector, or a marchand-amateur supervising a carpenter's work. The carpenter pulls nails out of the battens on the back and pries off the moldings of the frame so he can get to the individual panels. With saw in hand, he separates Madonnas from attendant saints, cuts the scenes of the predella, and lops off the pinnacles. He then smoothes the edges, regilds the backgrounds, and frames the panels separately. Bloodless work, but at day's end bits of color and gold undoubtedly glitter the sawdust.

Many such operations took place in the late eighteenth and early nineteenth century. For the carpenter, the task was not particularly demanding if we are to believe the invoice, dated 4 August 1771, of one Galgano Casini requesting minimal compensation for the assistant he sent to saw Duccio's great 1311 *Maestà* altarpiece into pieces. The front and back of the double-sided painting, once on the high altar of Siena cathedral, had been separated a month before, and were in an attic when Casini's worker arrived with a miter box (Figure 16). The Duccio was disassembled for storage reasons, but more often this activity occurred because a church had been closed. Beginning in the late 1700s, various Italian regional and national govern-ments (including those of Napoleon) shut religious establishments, forcing the retirement of priests and nuns and the confiscation of art, which was inventoried and removed to storerooms or public galleries.

The suppressions of churches stimulated study of early Italian art. While the breaking-up of the *Maestà* had not raised protests, its relegation to an attic later did. But thanks to the tireless efforts and publications of Guglielmo Della Valle,[1] a

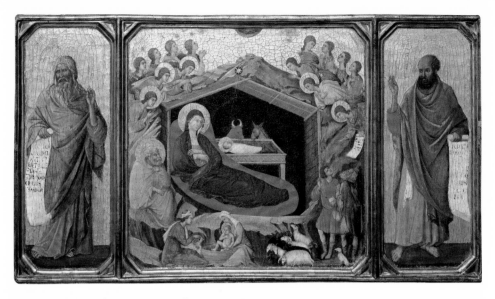

Figure 16 Duccio di Buoninsegna, *The Nativity with the Prophets Isaiah and Ezekiel*, cut from the rest of the *Maestà* in August 1771. Andrew W. Mellon Collection, National Gallery of Art. © 2001 Board of Trustees, National Gallery of Art.

Franciscan friar who briefly lived in Siena from 1780 to 1783, during which time he tracked old paintings and documents, there grew enough interest in Duccio as the founder of the Sienese school that the picture was reinstalled in the cathedral — the front and back in opposite chapels of the transept, and the predella and pinnacles, some of which were later sold, in the sacristy.

Della Valle's research on early Italian art began when he was asked to label a collection of medieval paintings created by the abbot Giuseppe Ciaccheri for the university library from recently closed religious communities. A similar awareness of early art was arising in other centers in Tuscany. Shortly thereafter, the ecclesiastic Alessandro Da Morrona, in an effort to stop the dispersal of sacred art in Pisa, published new discoveries in a detailed guidebook to the city.[2] Pisa soon hosted a diocesan museum founded in 1796 with a donation of art, in good part removed from suppressed churches, that the collector, the canon Sebastiano Zucchetti, stipulated was for the "decoration of the home town and the benefit of art students."[3] New galleries cropped up elsewhere. In 1789 in Florence, where the one public museum, the Uffizi, had not yet acquired much early art, the energetic Servite friar Raimondo Adami organized a museum in the church of Santissima Annunziata of "old works," including thirteenth-century panel paintings as well as Angelico's large silver reliquary cabinet, which eight years earlier a carpenter named Ponziani had sawn into eight convenient pieces at Adami's request (Figure 17).[4]

42

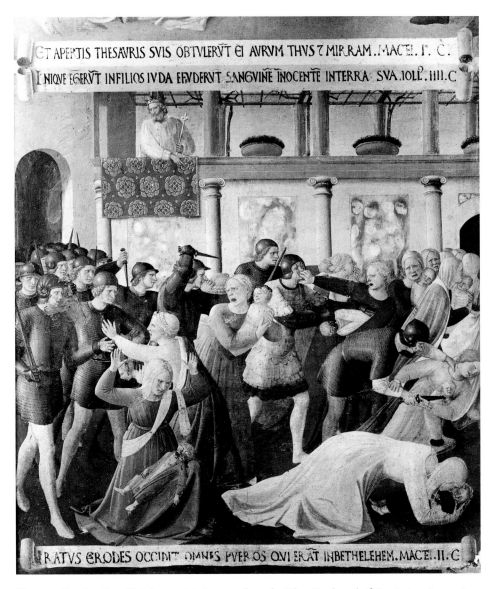

Figure 17 Fra Angelico, *The Massacre of the Innocents*, from the Silver Cupboard of Santissima Annunziata, Florence, disassembled by the carpenter Ponziani in 1781. Museo di San Marco.

But early Italian panels had fallen victim to carpenters' tools even before the practice became commonplace in the late 1700s. One of the first instances of a fragment's survival dates to the late 1480s. Bastiano Mainardi, a member of the workshop of Domenico del Ghirlandaio and later his brother-in-law, had painted a fresco on an interior wall of the Baroncelli chapel in Santa Croce in Florence focusing attention on the chapel's trecento altarpiece by Giotto. Mainardi had it reframed in the contemporary classicizing style replacing the gothic arched top with an entablature. This necessitated removal of the central pinnacle (Figure 18), which in 1957 was discovered in the San Diego Museum of Art.[5] Its unusual preservation is testimony to the Florentine reputation of Giotto, whose cult was then being promoted by Lorenzo de' Medici. The Medici collection already contained works from early centuries and Lorenzo's son Piero specifically sought out a diptych then attributed to Cimabue.[6] A taste for fragments did not exist. Even recently excavated ancient marbles were all provided with new arms and legs. The Baroncelli pinnacle either stayed with the donor family or, more probably, the Ghirlandaio workshop kept it as a souvenir. Florentine Renaissance artists being the first restorers, collectors, and enthusiasts of older art, Mainardi had restored at least one trecento fresco,[7] and Ridolfo del Ghirlandaio, the last artist in the family, owned a processional banner, then attributed to Masaccio, suggesting that he amassed early art ephemera.[8]

Since 1434, when the San Lorenzo building committee approved the architect Filippo Brunelleschi's wish that altarpieces for the new church should be square and without pinnacles,[9] Florentines had sent trecento pictures to be reframed.[10] Brunelleschi had not wanted his clean, modern design ruined by panels that aped the gothic. Such a decisive change in taste informed the conversion by Lorenzo di Credi in 1501 of a Fra Angelico altarpiece from a gold ground triptych to a single field picture with a painted background (Figure 19). The artist and critic Giorgio Vasari thought that the painting had turned out badly,[11] commenting favorably only on the predella, which was untouched. More often, old paintings were simply removed. During a visit to the cathedral of Siena, made after the first edition of his artists' biographies came out in 1550, Vasari made an effort to find Duccio's *Maestà*, which he had read about in the memoirs of the sculptor Ghiberti. He knew that it had been replaced in 1506, but information about its whereabouts was unavailable.[12] In Florence Vasari noted that Ugolino di Nerio's altarpiece, then in the chapter house of Santa Maria Novella, was once on the high altar.[13] Today it has completely disappeared; its replacement, an altarpiece by Domenico del Ghirlandaio, was later broken up and sold in 1804. In Santa Croce, Vasari designed the ciborium that took the place of another Ugolino di Nerio painting once on the high altar. That ciborium is now relegated to a side chapel, having been substituted around 1869 by an

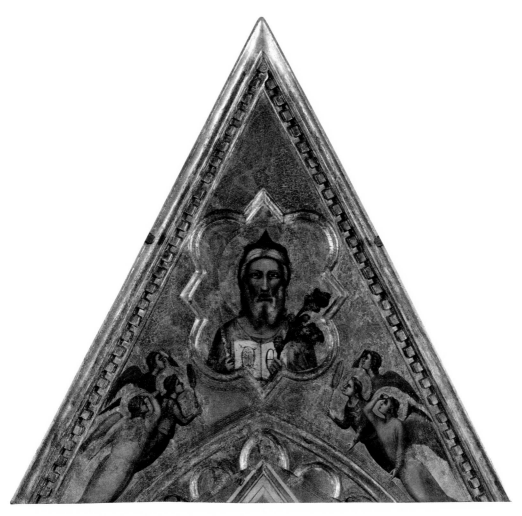

Figure 18 Giotto, *God the Father with Angels*, central pinnacle from the *Baroncelli Altarpiece* in Santa Croce, Florence. San Diego Museum of Art. Gift of Anne R. and Amy Putnam.

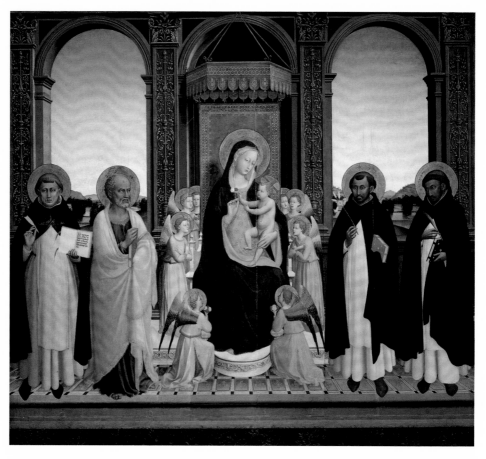

Figure 19 Fra Angelico, *Virgin and Child with Saints Dominic, Thomas, Barnabas, and Peter Martyr*, restored by Lorenzo di Credi in 1501. San Domenico, Fiesole.

altarpiece made up of pieces of trecento paintings. In 1785, Della Valle found the Ugolino in the friars' dormitory of Santa Croce,[14] creating enough interest that his friend, the French antiquarian Jean-Baptiste Séroux d'Agincourt had a drawing made showing it in a then-ruined state (Figure 20).

As architect of counter-reformation renovations of Santa Croce and Santa Maria Novella and Arezzo cathedral, Vasari destroyed much old art, taking down rood screens, whitewashing mural paintings, and installing new altars.[15] He did not escape criticism, but as author of the first history of art, the dissident voices have rarely been heard. Ecclesiastics, most concerned with tradition, were the harshest; Modesto Biliotti, a friar at Santa Maria Novella, commented on the sorrow caused by the loss of Masaccio's *Trinity*.[16] One could read about the fresco's marvelous per-

46

Figure 20 Drawing of Ugolino di Nerio's *Santa Croce Altarpiece* made for Jean-Baptiste Séroux d'Agincourt, MS. Vat. Lat. 9847 fol. 92r. Biblioteca Apostolica, Vatican City.

spective in Vasari's *Lives*, but in 1569, only a year after the second edition, Vasari covered it with his own altarpiece. It was not until 1861 that the fresco was seen again.

The first great dispersal of early art occurred in Rome when Old Saint Peter's was gradually destroyed as construction of the new basilica proceeded. Mosaic fragments were among the few things to survive. Some, like the one incorporated in 1609 into an altar in San Marco in Florence, are testimony to veneration for the old basilica, whereas others recently have been discovered, which were most likely collectors' curiosities (Figure 21).[17] Significantly, these artifacts were not panel paintings. The general late sixteenth-century distaste for that type of painting is best expressed by Giovan Battista Armenini's comments on "those so badly designed puppet-like figures on gold grounds that one can see in so many panels throughout Italy."[18] The attitude persisted, even though seventeenth-century antiquarianism, particularly in Rome, encouraged some preservation of old art. Drawings of medieval works in Roman churches commissioned by Cassiano dal Pozzo for his famous Paper Museum[19] are invaluable records of what those older monuments looked like before the great baroque renovations, during which an old sacred image

might be fitted into a sumptuous new altar or a medieval marble *gisant*, once in the sanctuary, walled in a cloister or sacristy.

Regional pride, a strong motivation in early Italian art scholarship, encouraged research on local schools. The seicento writer Carlo Cesare Malvasia in *Felsina pittrice* exalted Bolognese painters, often in violent reaction to Vasari's Florentine bias. As a result, Vitale da Bologna, a great trecento painter not discussed by Vasari, gets his due in lines that remained his main perceptive appreciation until the critic Roberto Longhi promoted him in a memorable 1950 exhibition on early Bolognese painting as an artist who established a "new poetic physiognomy."[20] Although Malvasia uncovered archival information about Vitale and meticulously sought his pictures, even climbing on a ladder to sponge frescoes to look for inscriptions,[21] unlike Longhi, he did not collect him. Gold ground painting did not merit a place in most picture galleries of the seicento. Thanks, however, to Malvasia's interest over a century before, Vitale's *Madonna de' denti* was awarded a plate (Figure 22) in the first general illustrated history of early art, by Jean-Baptiste Séroux d'Agincourt, first published in Paris between 1811 and 1820, but researched mostly in the 1770s and 1780s.[22]

The author, a well-connected French aristocrat, had settled in the via Gregoriana in Rome, where a visit to see not only his collection, but also his notes, drawings, and the plates that he was having made for the illustrations of his magnum opus, became an obligatory stop for foreigners on the grand tour. In July 1787, Goethe called on him and later wrote in his diary, published twenty-nine years after the event and as the Séroux d'Agincourt volumes were appearing, that if the Frenchman's work ever comes out, it will be noteworthy. The French Revolution delayed publication and ruined the author, who was lucky to have retrieved the plates that he had sent to Paris. Séroux d'Agincourt acknowledged that information was out-of-date, saying he had last seen some works about thirty years before.[23] He probably did not know that the saints at the sides of Vitale da Bologna's *Madonna* had in the meantime been made into separate pictures.

Séroux d'Agincourt is perhaps the most complete book on early Italian art by a foreigner: the result of a magnificent obsession. By the early 1800s several other publications announced to readers outside Italy a revival in the subject. This meant art before Raphael. To avoid any doubt, the French collector Jean-Alexis-François Artaud de Montor called his tome, first published in 1808, *Considerations on the State of Painting in the Three Centuries before Raphael.*[24] Over the next decade the Englishman William Young Ottley, who had spent years in Italy on research, began issuing illustrated books about Italian painting and sculpture, and, new for the period, about drawings and engravings. Ottley is undoubtedly the Englishman mentioned by Tommaso Puccini, director of the Uffizi from 1793 to 1811, as having bought Ugolino di Nerio's Santa

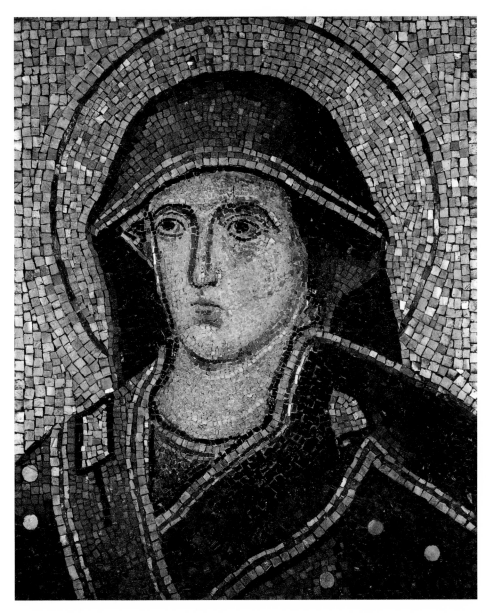

Figure 21 Jacopo Torriti, *Virgin and Child*, from the mosaic decorations of Old Saint Peter's, Rome. Brooklyn Museum of Art, New York.

Croce altarpiece for pocket money.[25] In 1835 the German Gustave Waagen traveling in England saw parts of it in Ottley's collection, indicating that the painting had probably been dismantled before being shipped home.[26]

While Ottley, Séroux d'Agincourt, Artaud de Montor, and the German Karl Friedrich von Rumohr, author of the scientifically titled *Italienische Forschungen*, or Italian investigations, publicized the wonders of early Italian painting to transalpine audiences, their research had a solid foundation in Italian erudition, which in 1792 produced an art historical masterpiece, Luigi Lanzi's *La storia pittorica della Italia inferiore*.[27] Lanzi was a Jesuit who, after the suppression of his order, became an employee of the Uffizi. His was the first book to organize the schools of Italian art systematically and to create a critical basis for the attribution of paintings, the recognition of individual styles, and the development of a style within a school. He also evaluated early artists like Cimabue and Giotto, not, as before, by literary tradition alone, but by what he thought they had actually painted. For example, the contrast between Lanzi's Cimabue, whose "talents did not consist in the graceful,"[28] and the lively French traveler Charles De Brosses, a friend of Diderot in Italy in the 1720s, for whom Cimabue's *Maestà* was no better than a decorated fire screen, and who believed Giotto to be not talented enough to paint a tennis court,[29] represents an enormous intellectual jump. Lanzi's still pertinent words on Giotto show his interest in drawing a picture of artistic culture along broad lines: "Giotto was the father of the new method of painting, as Boccaccio was called the father of the new species of prose composition. After the time of the latter, any subject could be elegantly treated in prose; after the former painting could express all the subjects of propriety."[30]

Lanzi had given the story of early Italian art an informed and readable narrative, and, subsequently, the great French novelist Stendhal, a frequent resident of Italy, who had also helped to inventory Napoleon's art loot, recognized Italian art history as a publishing opportunity. Having failed to get Lanzi translated into French, he wrote his own. Issued in 1817 under the pseudonym Monsieur Beyle, the *Histoire de la peinture en Italie* blatantly plagiarizes the Italian author as well as some of his predecessors, the eighteenth-century antiquarians who were the incorrigible seekers of the early art and documents that made Lanzi's achievement possible. They could be like Della Valle, who, in polemic with the Florentine bias of most art writing, exalted the Sienese school, or Da Morrona, whose guide to Pisa started a literary convention about reporting art discoveries in unlikely places such as, famously, finding a thirteenth-century crucifix by Giunta Pisano in a smoke-filled convent kitchen.[31] (In the 1850s, for the American James Jackson Jarves, it was Perugino in a monastery's wood storeroom.[32]) Della Valle not only tracked down the Ugolino di Nerio in the friary of Santa Croce in Florence, but also Simone

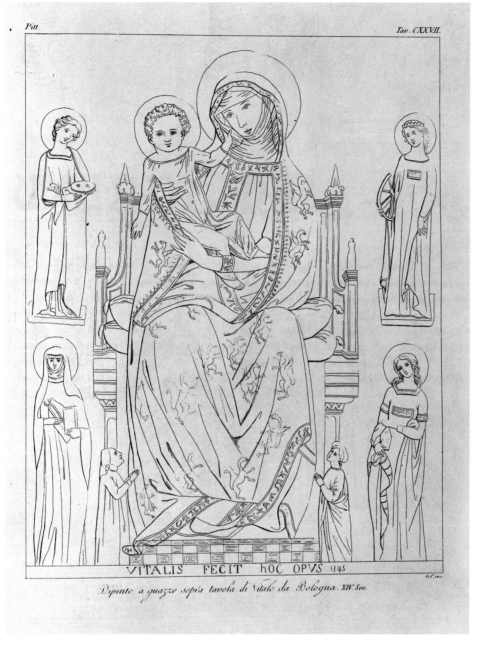

VITALIS FECIT hOC OPVS 1345

Dipinto a guazzo sopra tavola di Vitale da Bologna. XIV Sec.

Figure 22 Engraving of the *Madonna de' denti* by Vitale da Bologna from Jean-Baptiste Séroux d'Agincourt, *Histoire de l'art par les monumens*, London, 1847, (originally Paris, 1811–20). Yale Center for British Art, New Haven. Paul Mellon Fund.

51

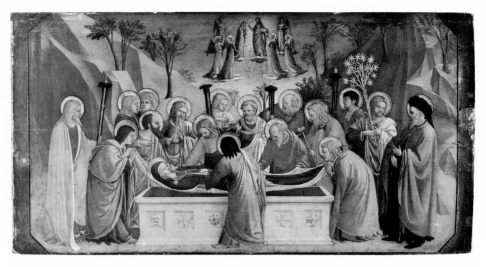

Figure 23 Fra Angelico, *Dormition of the Virgin*, with mid eighteenth-century restorations by Ignazio Hugford. John G. Johnson Collection, Philadelphia Museum of Art.

Martini's signed 1333 Annunciation altarpiece now famous, but once in Siena cathedral, in an out-of-use church. The latter discovery, made more magic by the literary fame of the artist as the portraitist of the poet Petrarch's beloved Laura, attracted the attention of Lanzi, who, with his colleague Tommaso Puccini at the Uffizi, got the grand duke Ferdinando III to exchange it for two paintings by the seicento artist Luca Giordano.

The Giotto name was another lodestone. In 1754 the historian of Florentine churches Giuseppe Richa wrote how important people offering to buy the artist's sacristy cupboard paintings in Santa Croce encountered the friars' refusal.[33] After the church's suppression in the early 1800s, these went to a depository where two Florentine dealers named Volpini and Brogi bought four pieces, which are now in Berlin and Munich.[34] Since attributed to Taddeo Gaddi, there was then no problem about the attribution to Giotto, as that is how they appeared in Vasari. But it was becoming necessary to find supporting documentation for the many fragments that were turning up.

Ignazio Hugford, a painter of some talent, an occasional faker of older works, and editor of the 1767–72 printing of Vasari's *Lives*, banked on his reputation as a Vasari scholar to identify a lost *Dormition of the Virgin* by Giotto. An inscription on the back of a predella panel now in Philadelphia (Figure 23) reports Hugford's opinion that it was a Giotto described by Vasari. While Hugford may not have realized that the panel was by Fra Angelico, he did know that it came from a predella, whereas Vasari spoke of an independent painting. Hugford abetted the deception by

52

cutting it and the other scenes of the predella, painted on a single plank, into separate works and by restoring the top of the panels that had been damaged in the process.[35] The *Dormition* was later engraved and appeared in Marco Lastri's *Etruria pittrice* of 1791 as a Giotto.

The engraving was by a printmaker from Treviso named Carlo Lasinio, who in 1807 was appointed keeper of the Camposanto in Pisa where while working both for the Tuscan and French governments he diligently collected art from suppressed churches, turning the place into a comprehensive museum of early Italian painting and sculpture. But he was also a dealer selling to foreign connoisseurs who crowded Italy, desirous of buying pictures. A drawing (Figure 24) sent to a British collector proves that the pictures were mostly fragments. Comments in the export papers, prepared by Lasinio himself and calling the works "panel fragments by the First Fathers of the Fine Arts," indicate that, although he officially had to prevent the export of integrate altarpieces, he felt no compunction about selling sections.[36]

During the reign of Napoleon, art had been systematically removed from churches to holding stations, such as the Camposanto, for inventory and selection for the new Musée Napoléon in the Louvre and its Italian branches, the Brera in Milan and the Accademia in Venice. In 1797 French officials started sending works to Paris, but not until after 1810 did anyone think of including what were called the primitives in a new installation in the Salon Carré of the Louvre, which opened on 25 July 1814. The idea came to Dominique-Vivant Denon,[37] director of the museum since 1803, who, having lived in Italy during the revolutionary terror in France, was well acquainted with the movement to study early art. In the autumn of 1811 he arrived in Florence, worrying local officials who thought that he would sack the Uffizi even though Puccini had already shipped many treasures for safekeeping in distant and English-held Palermo. When Napoleon had visited in 1796, he had been interested only in the classical statue of the Medici *Venus*, but Puccini properly surmised that Denon, who in the meantime had overseen the requisition of art in Germany, had a more discerning eye. That eye fell on paintings confiscated from Florentine churches that had been brought to the convent of San Marco, which had been turned into a depository. Denon was not wholesale in his choices. He could have had all of Gentile da Fabriano's 1423 *Adoration of the Magi* altarpiece, which was languishing there as inventory number 37, but instead he sent only a section of the predella to Paris. He also bought for himself two fragments of an Annunciation by Angelico, now in the Detroit Institute of Arts, which he hung with other curiosities like Peruvian antiquities in his rooms on the Quai Malaquais in Paris. He did, however, assure that Angelico's *Coronation of the Virgin* altarpiece from Fiesole went to the Musée Napoléon whole.

Committees in charge of returning art to the country of origin after Napoleon's fall were often less sympathetic to early art. The Gentile predella panel stayed in Paris, but the Tuscan committee also neglected to return Angelico's altarpiece as well as other Denon picks: Cimabue's *Maestà* and Giotto's *Stigmatization of Saint Francis*, both from Pisa, of which the latter even bore a signature. The great sculptor Canova, commissioner for the repatriation of art in the Papal States, saw that Angelico's Perugia altarpiece made it back, but parts of the predella were sent to the Vatican, probably at the urging of Pius VII, who wanted a picture of the friar painter whose reputation was then at its height in religious and artistic circles; in 1814 Canova had even commissioned a bust of the artist for the Roman Pantheon.

No other early painter was so celebrated. On his first trip to Florence in 1845 John Ruskin passed days in the sacristy of Santa Maria Novella drawing Angelico's reliquary of the Annunciation. In 1849 the Boston sculptor William Wetmore Story braved the Austrian troop occupation of San Marco to view Angelico's frescoes, noting that the painter's "suavity" was at odds with the odor of the soldiers' perspiration. Even after the soldiers had cleared out, artists needed official permission to sketch there, something Manet, in 1857, and Degas the next year, duly took the trouble to obtain. Nathaniel Hawthorne went there and to the Accademia around the same time but was impervious to Angelico's charm, taking "little or no pleasure in his work"[38] as did also Henry James later in his *Italian Hours*, evidence that the artist had become common tourist prattle. The place had been the exclusive preserve of male tourism until 1869, at which time the female public was finally let in to what had become the first monographic museum dedicated to an Italian painter.[39] This renewed interest in Angelico is perhaps what persuaded, probably some decades later, a counterfeiter to remove and replace with a copy a section of Angelico's silhouetted crucifix group in the Florentine chapel of San Niccolò del Ceppo showing Saint Francis. Now in the Philadelphia Museum of Art, it has been restored to its original shape, but, at the time of its sale, it had been made up into an easel painting showing the saint in prayer (Figures 25 and 26). Deceptive restorations like the recomposition of the Annunciation from the triptych wings in this exhibition are another example of the market demand created by Angelico's prestige. Outright falsification was much less common than such fine tuning of small, readily available fragments.

Describing the enthusiasm of American collectors who delved into the art market of mid nineteenth-century Italy, Henry James wrote that "the gold was far from all rubbed off,"[40] meaning the pursuit was as glittering as the gold grounds of the paintings they were pursuing. James was referring to William Wetmore Story, who, after his encounter with the soldiers at San Marco, had gone "picture-hunting and

Figure 24 Carlo Lasinio, Drawing of Italian Panel Paintings sent to Francis Douce in 1829, MS. Douce d.57 fol. 84. Bodleian Library, University of Oxford.

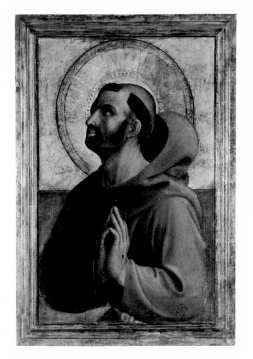 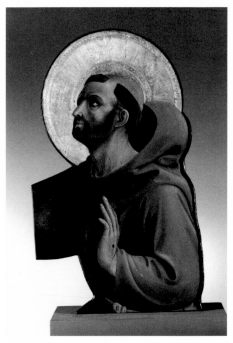

Figure 25 Fra Angelico, *Saint Francis*, before restoration in 1992 to its original shape. John G. Johnson Collection, Philadelphia Museum of Art.

Figure 26 Fra Angelico, *Saint Francis.* John G. Johnson Collection, Philadelphia Museum of Art.

buying all day long." Vast quantities were available, if another American, James Jackson Jarves, whose collection forms the basis of Italian art at Yale, was truthful when he wrote to Harvard professor Charles Eliot Norton about buying on one occasion forty-four pictures to obtain the one he wanted.[41] Such numbers were not uncommon: In 1838 the German artist and connoisseur Johann Anton Ramboux had sent two hundred twenty-six Sienese panels to Germany.[42] James called the hunt for early art the "golden quest," but before the collectors and connoisseurs landed their quarry, it had been to the carpenters.

NOTES

1. *Lettere sanesi . . .* , Venice and Rome, 1782–86.

2. *Pisa illustrata . . .* , Pisa, 1787–93.

3. Enzo Carli, *Il museo di Pisa*, Pisa, 1974, p. 4.

4. Eugenio Casalini, *La SS. Annunziata di Firenze*, Florence, 1971, pp. 44 n. 41, 65 n. 39. He was criticized by fellow friar Costantino Bettini for removing and cutting up art (pp. 65–66 n. 42).

5. Federico Zeri, "Due appunti su Giotto," *Paragone*, VIII: 85, 1957, pp. 75–87.

6. Luciano Bellosi, "Un Cimabue per Piero de' Medici e il Maestro della Pietà di Pistoia," *Prospettiva*, LXVII.

7. Lisa Venturini in Mina Gregori et al., *Maestri e botteghe*, Cinisello Balsamo, 1992, p. 214.

8. Philadelphia Museum of Art (Johnson Collection cat. 17). Giorgio Vasari, *Le vite*, eds. Rosanna Bettarini and Paola Barocchi, text II, Florence, 1971, p. 126 [henceforth Vasari, Bettarini and Barocchi ed.].

9. Jeffrey Ruda, "A 1434 Building Programme," *Burlington Magazine*, CXX, 1978, p. 361, and Carl Brandon Strehlke, *Angelico*, Milan, 1998, p. 21.

10. Cecilia Filippini in Gregori et al., *Maestri e botteghe*, pp. 199–211.

11. Vasari, Bettarini and Barocchi ed., text vol. III, Florence, 1971, pp. 270–71.

12. Ibid., text II, 1967, p. 260.

13. Ibid., p. 139.

14. Della Valle, *Lettere*, II, 1785, p. 202.

15. Marcia B. Hall, *Renovation and Counter-Reformation*, Oxford, 1979.

16. Modesto Biliotti, *Chronica pulcherrimae*, Florence, 1586, p. 48.

17. Alessandro Tomei in Marina Righetti Tosti-Croce ed., *Bonifacio VIII e il suo tempo*, Milan, 2000, p. 140.

18. Giovan Battista Armenini, *De' veri precetti della pittura*, ed. Marina Gorreri, [Ravenna, 1587], Turin, 1988, pp. 1–2.

19. John Osborne and Amanda Claridge. *The Paper Museum of Cassiano dal Pozzo, II: Early Christian and Medieval Antiquities*, 2 vols., London, 1996–97.

20. *Edizione delle opere complete*, VI: *Lavori in Valpadana*, Florence, 1973, p. 157.

21. Giovanni Previtali, *La fortuna dei primitivi*, [1964], revised ed., Turin, 1989, p. 52.

22. *Histoire de l'art par les monumens depuis sa décadence au IVe siècle, jusqu'à son renouvellement au XVIe.* Another French printing and an Italian translation soon followed.

23. Ibid., III, 1823 ed., p. 138.

24. *Considérations sur l'état de la peinture dans les trois siècles qui ont précedé Raphaël.*

25. Gaetano Milanesi in Giorgio Vasari, *Le vite*, I, Florence, 1878, p. 454.

26. *Kunstwerke und Künstler in England und Paris*, I, Berlin, 1837, pp. 393–95.

27. The first full edition came out in Bassano in 1795–96. An abridged French edition appeared in 1823, and a complete one the following year. The book was translated into German in 1830, and into English by Thomas Roscoe in 1847. Martino Capucci edited the modern critical edition (Florence, 1968–74).

28. Roscoe's translation (I, 1847, p. 42) for "vasto e macchinoso nelle idee (Capucci ed., I, 1968, p. 22)."

29. Previtali, *La fortuna*, pp. 195–96. The "Cimabue *Maestà*" is actually Duccio's 1285 *Rucellai Madonna*, identified as by the Sienese master only in the twentieth century.

30. Roscoe's translation (I, London, 1847, p. 54).

31. Da Morrona, *Pisa illustrata*, 1787–93, 1812 ed., II, p. 135.

32. Francis Steegmuller, *The Two Lives of James Jackson Jarves*, New Haven, 1951, p. 172.

33. Giuseppe Richa, *Notizie istoriche*, I, Florence, 1754, p. 66, in Previtali, *La fortuna*, p. 212.

34. Miklós Boskovits, *Frühe Italienische Malerei*, Berlin, 1987, p. 41.

35. Carl Brandon Strehlke in Laurence B. Kanter et al., *Painting and Illumination in Early Renaissance Florence 1300–1450*, New York, 1994, pp. 326–32, and Laurence B. Kanter, "A Rediscovered Panel by Fra Angelico," *Paragone*, LI: 599, 2000, pp. 3–13.

36. Donata Levi, "Carlo Lasinio, Curator, Collector and Dealer," *Burlington Magazine*, CXXXV, 1993, p. 135.

37. Monica Preti Hamard in *Dominique-Vivant Denon: L'oeil de Napoléon*, Paris, 1999, pp. 226–53.

38. *The French and Italian Notebooks*, ed. Thomas Woodson, Columbus, Ohio, 1980, pp. 323, 368–70.

39. Hawthorne had handily used the exclusion of his wife as a reason for not visiting the upper floor in 1858.

40. Henry James, *William Wetmore Story and his Friends*, I, London, 1903, p. 165.

41. Steegmuller, *Jarves*, p. 171.

42. Letter to J. D. Passavant dated 23 September 1838 in Hans-Joachim Ziemke, "Ramboux und die sienesische Kunst," *Städel Jahrbuch*, n.s., II, 1969, pp. 286–87 n. 8.

The typefaces used in the composition of this book are digital versions of Centaur Roman, designed by Bruce Rogers, and Arrighi Italic, designed by Frederic Warde. Centaur is based upon the roman letterform used by Nicolaus Jenson for his *Eusebius* printed at Venice in 1470. Arrighi is modeled on a Chancery italic type from 1524 designed by the Venetian writing master Ludovico degli Arrighi. Centaur and Arrighi were issued as companion typefaces and made available for mechanical composition in 1929 by The Monotype Corporation of England. The digital fonts used here are derived from the Monotype versions of both Centaur and Arrighi.

Printed by Meridian Printing Company, East Greenwich, Rhode Island

Bound by Acme Bookbinding Company, Charlestown, Massachusetts

Design & Typography by Howard I. Gralla